llen, ..."fun"
reative fun
for a creative friend...
merry Christmas 1998
Joan

Between
reality
and
illusion
the
artist
builds
a
Bridge
of
Creativity
...once
taken,
an
adventure
begins.
Have Fun.

To Marilyn,
(my concrete mixer)
I dedicate this Bridge
to you.

Jay Palefsky

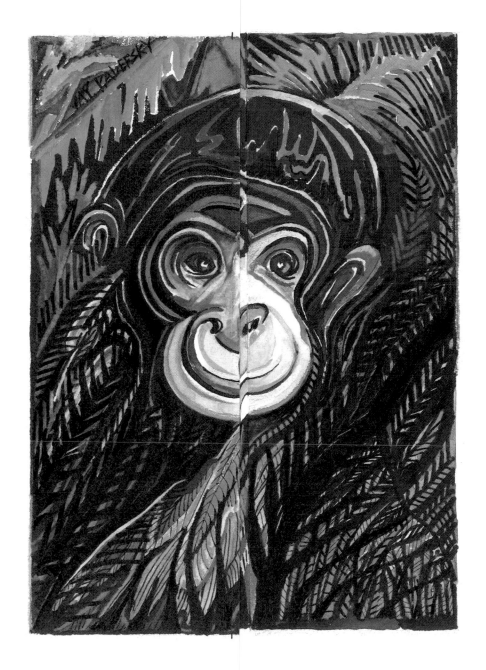

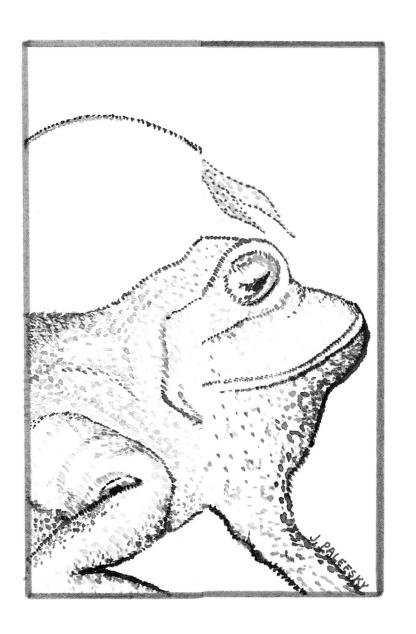

ONCE UPON A TURN

Owl always remember
And never **Froget**,
When the Princess
kissed an Owl
Just before sunset.

Feeling highly romantic
He crooned out a tune;
Later on, I've been told
He turned into a Moon.

Owl always remember
And never **Froget**,
When the Princess
kissed a Frog
The same day they met.

Feeling royally enchanted
He hopped up and down;
Later on, I've been Toad,

...He turned into a Clown.

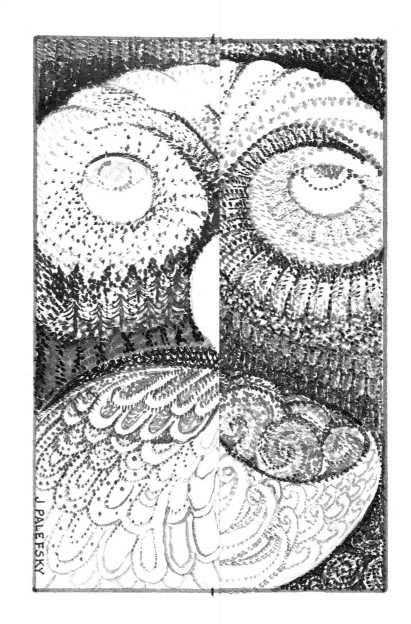

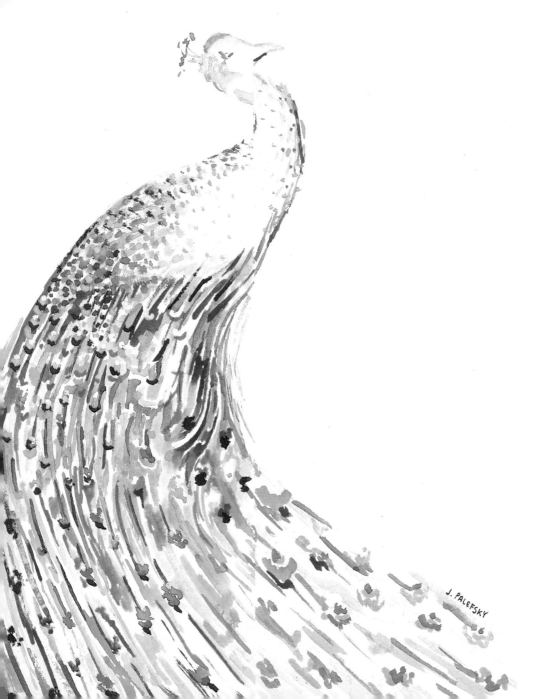

BEYOND
EDEN

Wherever
You Plant
Seeds
Of
Imagination,
Magic,
and
Wonder,
A
Garden
Of
Creativity,
Dreams,
and
Adventure,
Will
Begin to
Grow. . . .

J. PALEFSKY

and grow and grow.

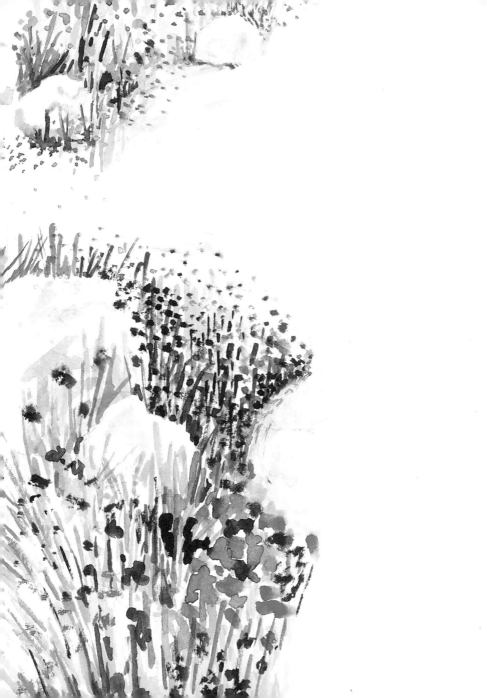

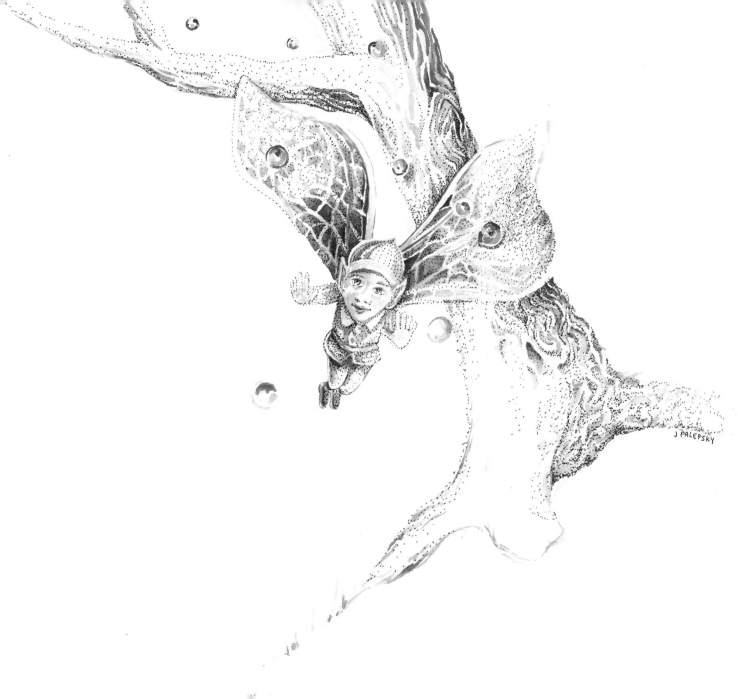

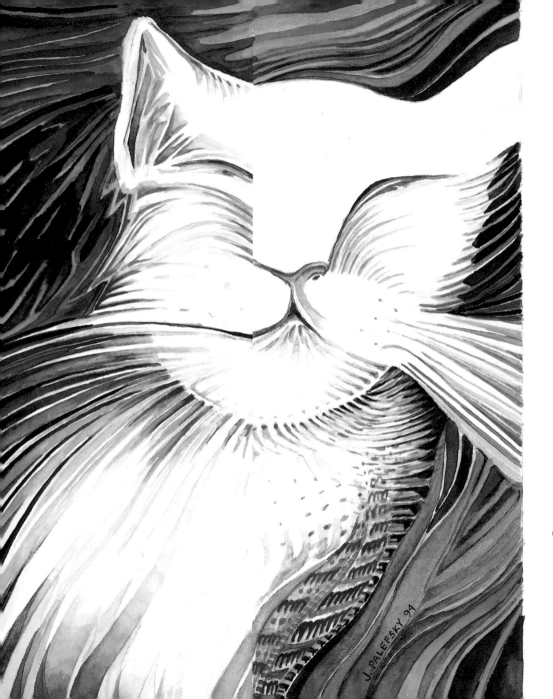

A STRANGE EXCHANGE

"Yow," said Mee,
"Let us chatter
about life
and other things
that matter."

"Mee," Yow replied,
"I'd rather scatter
to gather matter,
so I can have lunch
and become . . .

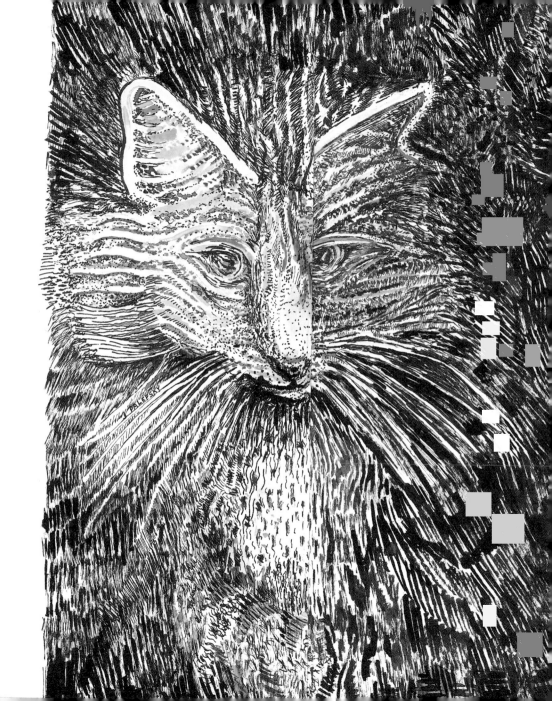

a fatter catter."

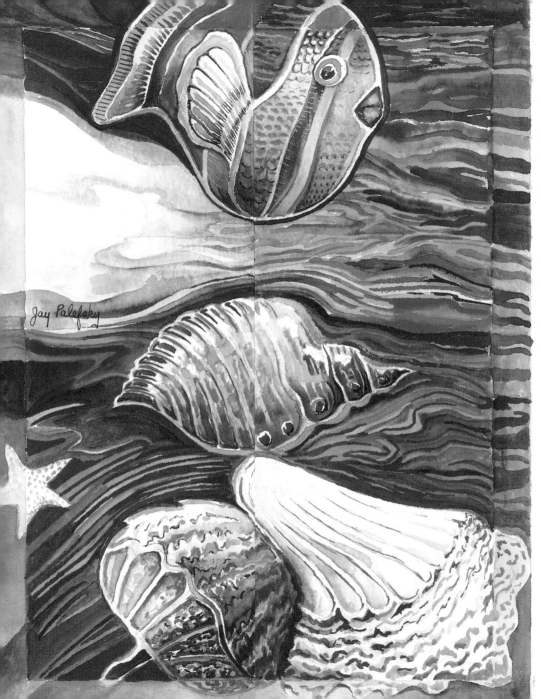

ENTER DREAMING

What happens
When
Nighted eyes
Close
Letting the sea
And the stars
Kiss?

What happens
When
Castled clouds
Sail
Over distant lands
And love-swept
Ships?

What happens
At that moment?

What happens
 is this . . .

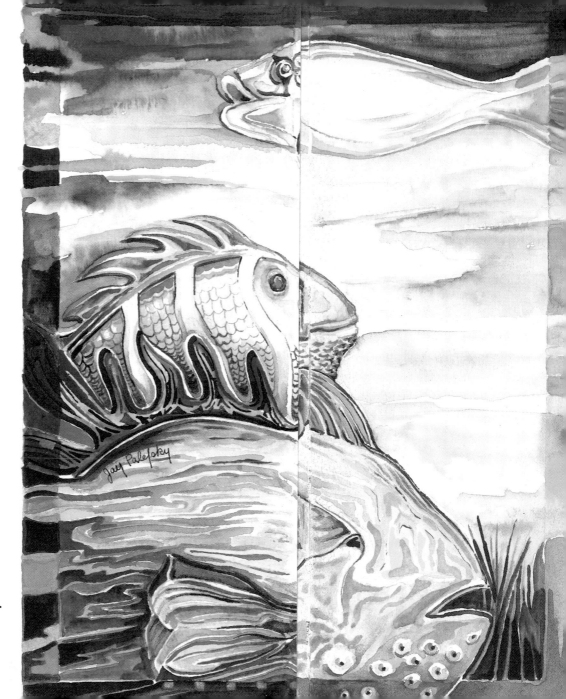

A Fantasea Begins.

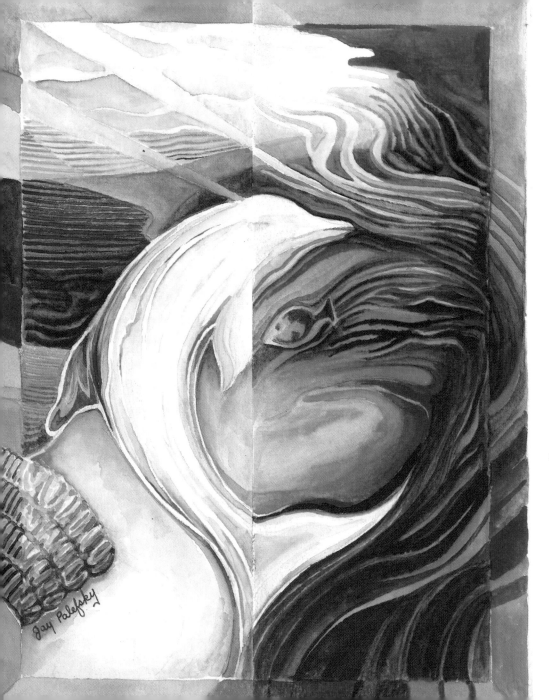

Jay Palefsky

A
CHANGE
OF
"SEA"NERY

I watch you at work,
I watch you at play,
I watch your
dreams come true;
And
I watch you so
carefully
show me the way,
As I watch myself
changing . . .

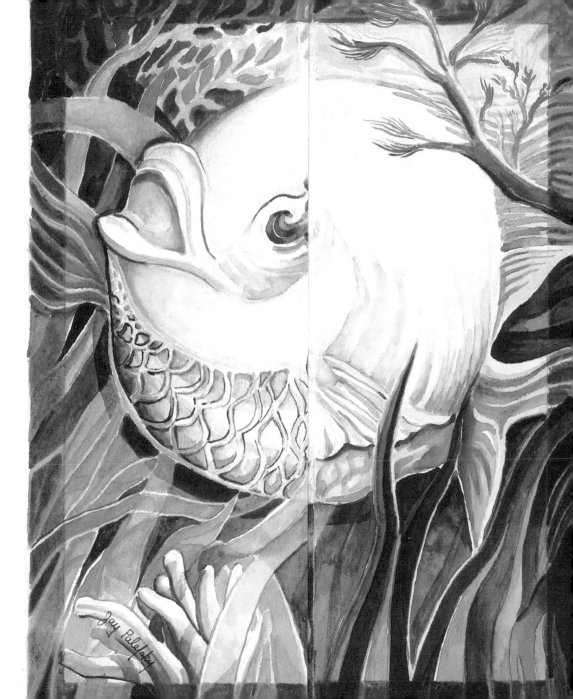

from me into you.

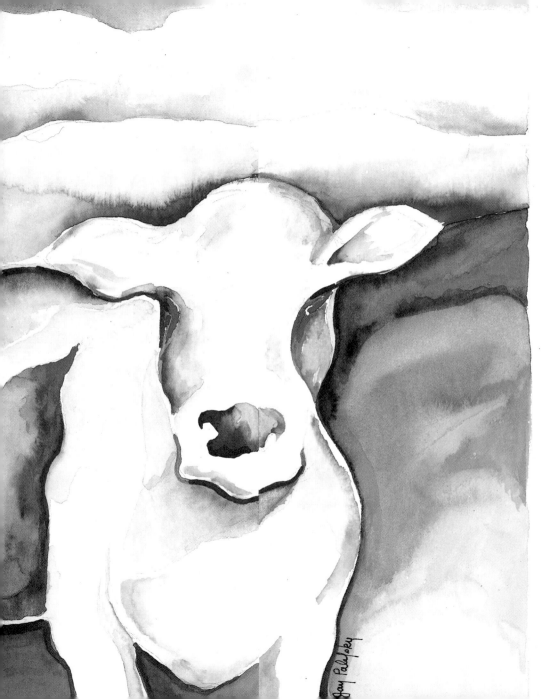

THE
UDDER
SIDE OF
OPPORKTUNITY

I ham young
and
ewe are not
pasture prime.

Pigture us
mooving into a
two-story horse
clover - looking
a meadow.

Our relationsheep
is eggciting
and sow calfree.
We were barn . . .

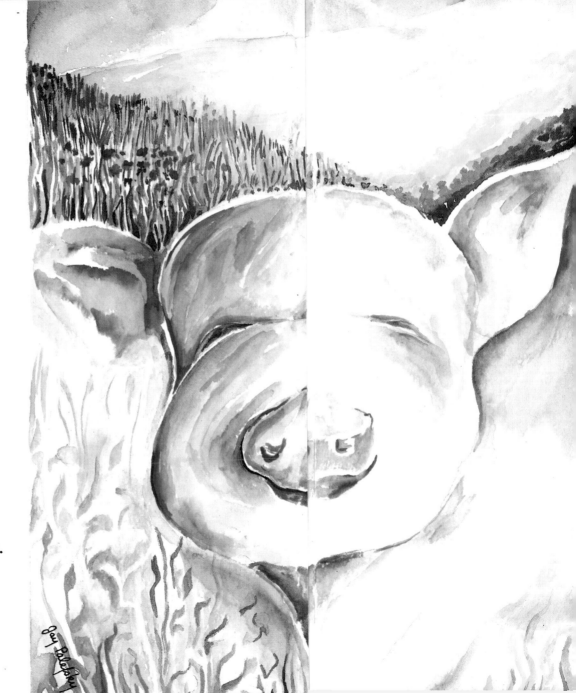

to raise a farmily.

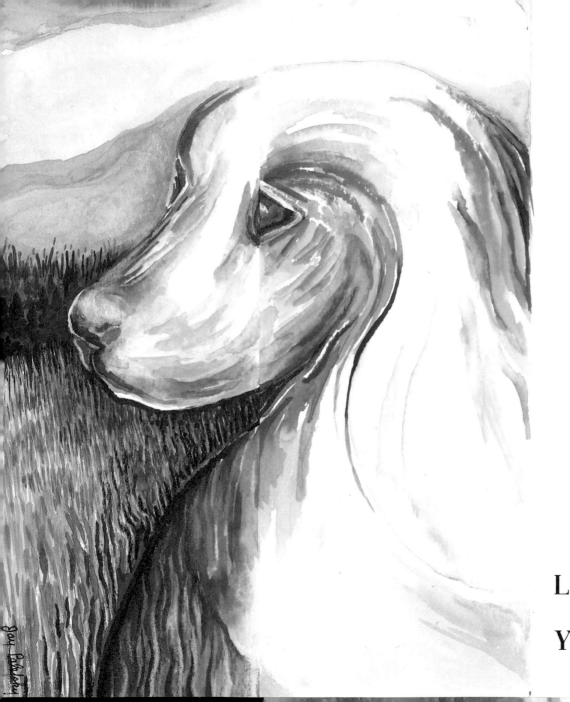

INSIGHT

If you can
see
Each day
with
Laughing eyes
then
You will stay . . .

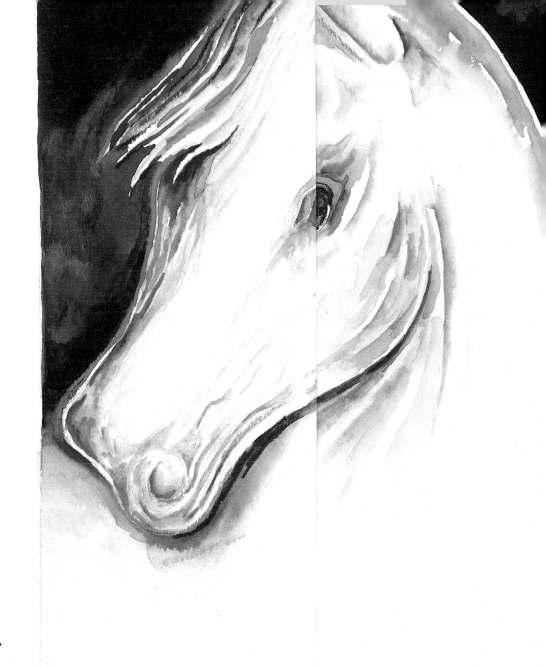

Young forever.

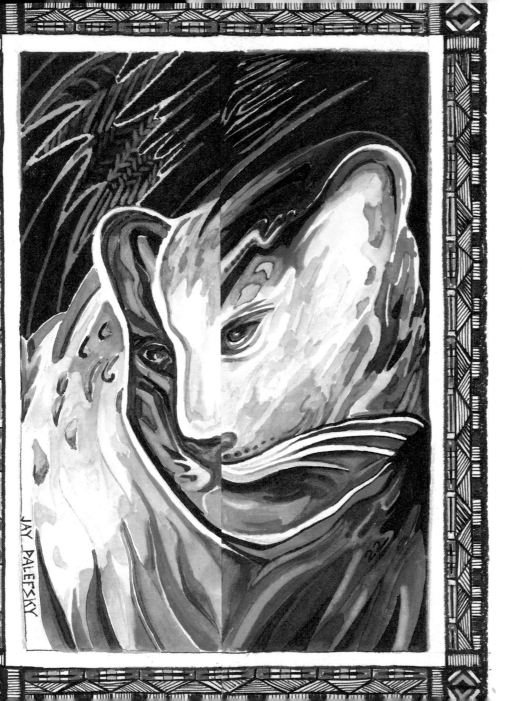

JAY PALEFSKY

HIDDEN TREASURES

If
You
Get Lost
In the
Journey
Through
Life,

Just
Follow
Your
Heart
So
You Can
Find . . .

The Way Home.

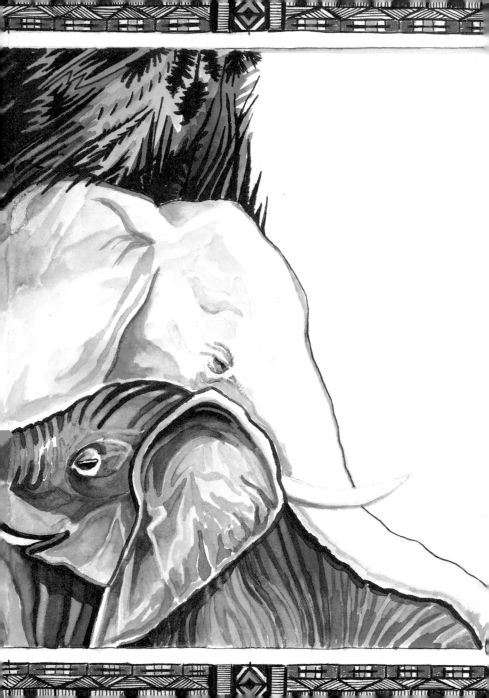

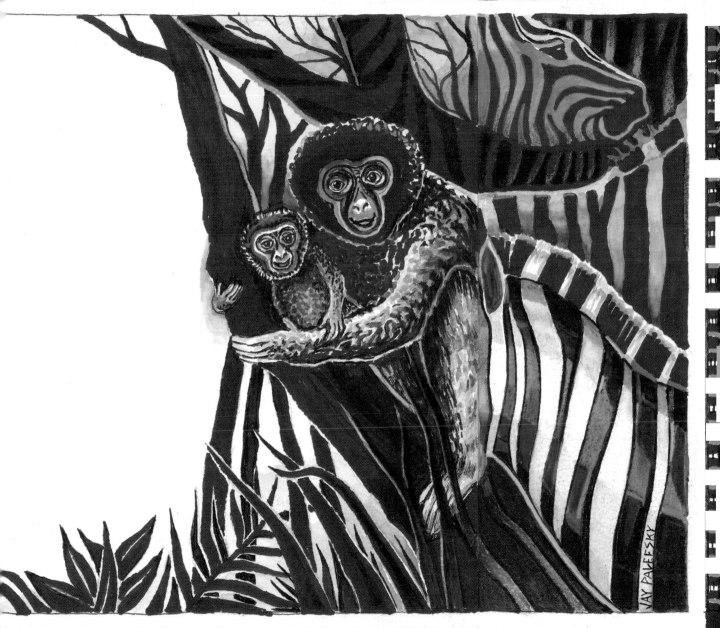

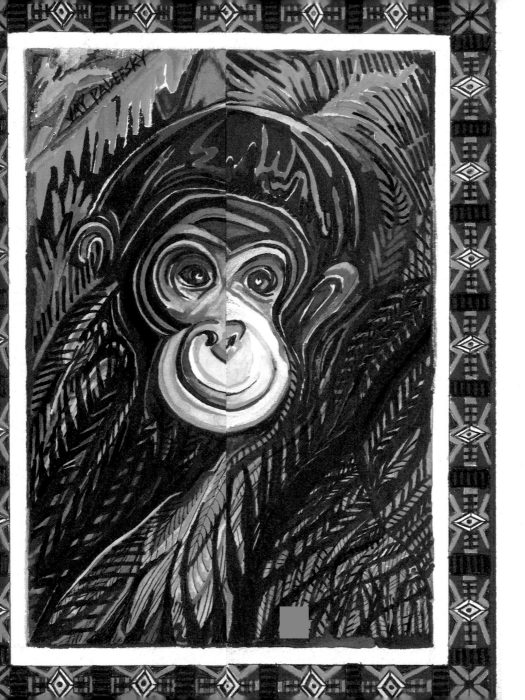

ON THE
WILD SIDE

When the she
MONKEY
sang to

hiM-ON-KEY,

there came a roar
from the
JUNGLING crowd.

For only
in **PARROT**ise,
you see,
could there
BEE
such
ELEPHANTastic
harmony,

Where
everyone could . . .

GIRAFFE out loud.

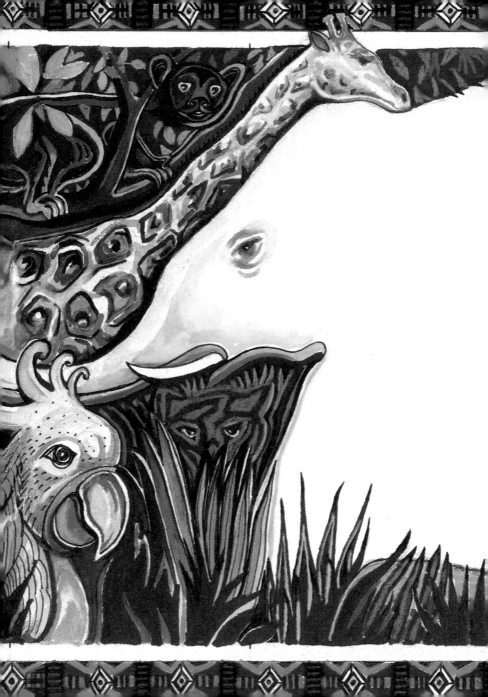

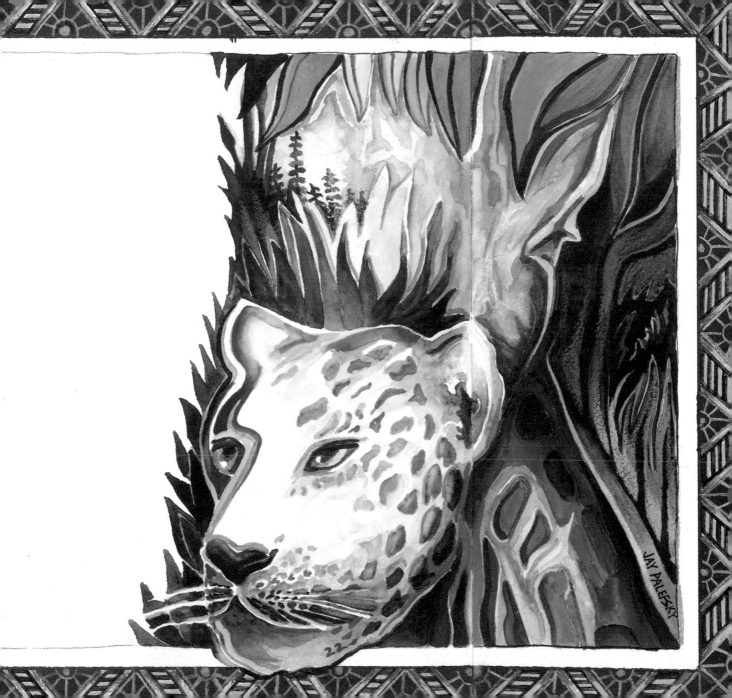